AVOCUDDLE

First published in Great Britain in 2019 by Pyramid,
an imprint of Octopus Publishing Group Ltd, London.

Published in 2020 by
Harper Design
An Imprint of HarperCollins*Publishers*
195 Broadway
New York, NY 10007
Tel: (212) 207-7000
Fax: (855) 746-6023
harperdesign@harpercollins.com
www.hc.com

Distributed throughout North America by
HarperCollins Publishers
195 Broadway
New York, NY 10007

ISBN 978-0-06-298535-4

Printed in China
First Printing, 2020

Publisher: Lucy Pessell
Designer: Lisa Layton
Editor: Sarah Vaughan
Assistant Production Manager: Lucy Carter

AVOCUDDLE

comfort words for when you're feeling downbeet

To: ...

From: ...

HARPER DESIGN

An Imprint of HarperCollins Publishers

YOU BRING

CHIA TO MY LIFE

YOU ARE
SOMEONE'S
RAISIN TO SMILE

YOU WILL ACHIEVE
GRAPENESS

I WILL ALWAYS
BAYLEAF IN YOU

IT'S THYME TO TURNIP THE BEETS

AND GIVE YOURSELF A HIGH CHIVE

OH MY GOURD
YOU'RE AWESOME

YOU'RE NOT THE ONLY
PERSON IN THE UNIVERSE,
BUT YOU'RE THE ONION
THAT MATTERS

NEVER FIGET THAT I LOVE YOU

I YAM
ALWAYS
HERE FOR YOU

YOU WILL ALWAYS
BE MY FIRST CHOYS

I CHERRYSH YOU

"DO THINGS TO
SALSIFY YOUR OWN SOUL"

JUSTIN GAFFREY

THYME IS PRECIOUS,
SO ARE YOU

HOLY SHIITAKE
YOU ARE AWESOME

PEAS
ROMAINE
CALM
AND
CARROT
ON

"YOU CAN AND YOU SHOULD,
ENDIVE YOU'RE BRAVE
ENOUGH TO START, YOU WILL"

STEPHEN KING

YOU HAVE
ALL MY ENCOURAGEMINT

IF YOU ARE
GOING TO
RICE, YOU
MIGHT AS
WELL SHINE

LETTUCE NEVER BE PARTED

YOU ARE THE
YIN TO MY YAM

LIFE IS A
JOURNEY AND
ONLY YOU HOLD THE KIWI

IN ORDER TO SUCCEED,
WE MUST FIRST BAYLEAF THAT WE CAN

YOU'RE AWESOME TO THE CORE

THERE IS NO
"ME"
WITHOUT
"YOU."
YOU ARE MY
MISSING PEAS.

THERE'S SO MUSHROOM
IN MY HEART FOR YOU

**THERE ARE SO MANY
RAISINS TO BE HAPPY**

YOUR SMILE IS
LIKE THE SUNRICE

PEAS BE WITH YOU

HAVE A HUG.
JUST COS

Sprout wings and fly

YOU CORN
COUNT ON ME

YOU FIGGIN' ROCK

"HEY MR. TANGERINE MAN, PLAY A STRAWBERRY..."

BOB DYLAN

#wejammin

YOU'RE SO SWEDE

I MINT WHAT I SAID,
YOU ARE AWESOME

YOU HAVE NO IDEA
HOW HARD IT IS
TO FORCE MYSELF
TO STOP THINKING
ABOUT YUZU
SOMETIMES

You're a little gem

BEETROOT TO YOURSELF

DON'T DISPEAR,
I AM THERE

ENDIVE I ASKED YOU TO NAME ALL THE THINGS THAT YOU LOVE, HOW LONG WOULD IT TAKE FOR YOU TO NAME YOURSELF?

OLIVE YOU WITH ALL MY HEART

I'll be there to cashew if you fall

YOU ARE BEETROOTIFUL...
MY QUEEN BEET

YOU'RE JUST PEARFECT

ALOE
SUNSHINE!

YOU ARE AMAIZEING

BEING FRIENDS
WITH YUZU MAKES
EVERY MORNING WORTH
GETTING UP FOR

IT'S ABOUT
LOVING WHAT YOU HAVE
AND BEING GRAPEFUL FOR IT

DON'T WORRY BE HAPPEA

YOU MAKE MISO

FIGGIN' HAPPY

WORRYING DOES NOT TAKE AWAY TOMORROW'S TROUBLES, IT TAKES AWAY TODAY'S PEAS

IF YOU
BAYLEAF IN
YOURSELF,
ANYTHING IS
POSSIBLE

DON'T BERRY YOUR FEELINGS

PEAS KNOW
HOW GRAPE YOU ARE

DO WHATEVER
FLOATS YOUR OAT

LETTUCE
ALWAYS
ROMAINE
TOGETHER

"IT IS SAD TO GROW OLD
BUT NICE TO RIPEN"

BRIGITTE BARDOT

YOU'RE THE ZEST

DON'T FIGET

TO BREATHE

SOY I'VE BEAN
THINKING OF YOU

TOMARROW
IS A NEW DAY

I'D GUAVA BE NEXT TO YOU

I WOULDN'T CHIANGE A
THING ABOUT YOU

MY HEART BEETS FOR YOU

LOVE LIKE THERE'S
NO TOMORROW,
ENDIVE TOMORROW
COMES, LOVE AGAIN

"I BAYLEAF IN MIRACLES, SINCE YOU CAME ALONG..."

HOT CHOCOLATE

FIND JOY IN THE LENTIL THINGS

CELERYBRATE THE
GOOD THYMES

AND NEVER CELERY
YOURSELF SHORT

I AM SO
GRAPEFUL THAT I KNOW YOU

BREATHE, SMILE, AND GO CARPE THE SHIITAKE OUT OF THIS DIEM

MAKE EACH DAY
YOUR MASTERPEAS

THE SUN WILL
COME OUT TOMARROW

WORLD PEACE

BEGINS WITH INNER PEAS

"YOU MUST ROMAINE
CALM ON YOUR JOURNEY
TO GRAPENESS"

LES BROWN

IGNORE THE
HUSTLE AND BRUSSEL

ALOE YOU VERA MUCH

YOU ARE
24 CARROT GOLD

IT DOESN'T
MATTER HOW
SLOE YOU
GO AS LONG
AS YOU
DON'T STOP

"IF YOU WANT TO ACHIEVE GRAPENESS, STOP ASKING FOR PERSIMMON"

FAZMIEWAR

I THINK YOU ARE SUBLIME

"LETTUCE ALWAYS MEET
EACH OTHER WITH A SMILE,
FOR THE SMILE IS THE
BEGINNING OF LOVE"

MOTHER TERESA

YOU ARE A
PEASHOOTING STAR

YOU OKALE HUN?

GOOD THINGS CUMIN GOOD THYME

Peas be gentle on yourself

"SOOOOOME
PEAR OVER THE
RAINBOW"

YIP HARBURG

YOU ARE THE
LIGHT THAT
NEVER GOES
SPROUT

EXIST ON YOUR OWN TURM(ERIC)S*,
THAT IS ALL

*OUR SINCERE APOLOGIES. IF YOU CAN DO SOMETHING
BETTER WITH "TURMERIC," WE'D LOVE TO HEAR FROM YOU.

For those of you who haven't herb enough, and haven't herb-it-all-bivore, this series has all the chiaing things you've ever wanted to say in vegan-friendly puns*.

Find the pearfect gift for any occasion:

AVOCUDDLE
comfort words for when you're feeling downbeet

YOU ARE 24 CARROT GOLD
words of love for someone who's worth their weight in root vegetables

*Or plant-based puns if, like us, you are no longer sure if avocados are vegan. Or friendly.

AVOCUDDLE

comfort words for when
you're feeling downbeet

YOU ARE
24 CARROT
GOLD

words of love for someone
who's worth their weight in
root vegetables

Acknowledgments and Apologies

With thanks to Andrew, Anna, Steph, Alison and Matt for their contributions, and special thanks to Joe as his contributions were really quite good.

We regret not being able to do anything with cavolo nero, kohlrabi, sorrel and fenugreek. We hold anyone who can in the highest regard.

"patience is bitter but its fruit is sweet"
Aristotle